THE ART OF
MICKEY MOUSE

A Disney Miniature

THE ART OF
MICKEY MOUSE

Edited by
CRAIG YOE and JANET MORRA-YOE

Introduction by
JOHN UPDIKE

NEW YORK

INTRODUCTION

JOHN UPDIKE

It's all in the ears. When Mickey Mouse was born in 1928, the world of early cartoon animation was filled with two-legged zoomorphic humanoids, whose strange half-black faces were distinguished one from another chiefly by the ears. Felix the Cat had pointed triangular ears and Oswald the Lucky Rabbit—Walt Disney's first successful cartoon creation, which he abandoned when his New York distributor, Charles Mintz, attempted to swindle him—had long, floppy ears, with a few notches in the end to suggest fur. Disney's Oswald films, and the Alice animations that preceded them, had mice in them, with linear limbs, wiry tails, and ears that are oblong, not yet round. On the way back to California from New York

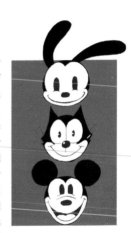

Walt Disney's Oswald the Rabbit, Otto Messmer's Felix the Cat, and early Mickey Mouse.

Felix is © Felix the Cat Productions, Inc. and appears with the kind permission of Don Oriolo.

by train, having left Oswald enmeshed for good in the machinations of Mr. Mintz, Walt and his wife Lillian invented another character based—the genesis legend claims—on the tame field mice that used to wander into Disney's old studio in Kansas City. His first thought was to call the mouse Mortimer; Lillian proposed instead the less pretentious name Mickey.

Somewhere between Chicago and Los Angeles, the young couple concocted the plot of Mickey's first cartoon short, *Plane Crazy*, co-starring Minnie and capitalizing on the Charles Lindbergh craze of 1927. The next short produced by Disney's fledgling studio—which included, besides himself and Lillian, his brother Roy, and his old Kansas City associate, Ub Iwerks—was *Gallopin' Gaucho*, and introduced a fat and wicked cat who did not yet wear the prosthesis that would give him the name of Pegleg Pete. The third short, *Steamboat Willie*, incorporated that brand-new novelty,

a sound track, and was released first. In 1928 Mickey Mouse entered history as the most persistent and pervasive figment of American popular culture in this century.

His ears are two solid black circles, no matter the angle at which he holds his head. Three-dimensional images of Mickey Mouse—toy dolls, or the giant costume heads the grotesque Disneyland Mickeys wear— make us uneasy, since the ears inevitably exist edgewise as well as frontally. These ears properly belong not to three-dimensional space but to an ideal realm of notation, of symbolization, of cartoon resilience and indestructibility. In drawings, when Mickey is in profile, one ear is at the back of his head like a spherical ponytail, or like a secondary bubble in a computer-generated Mandelbrot set. We accept this phenomenon, as we accepted Li'l Abner's hair always being parted on the side facing the viewer. A surreal optical consistency is a part of the

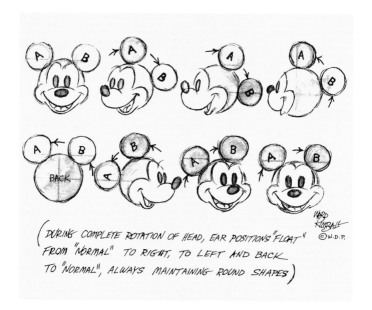

A B → A B → A B A B

A B ← B A B A B A B

BACK

WARD KIMBALL ©W.D.P.

(DURING COMPLETE ROTATION OF HEAD, EAR POSITIONS "FLOAT" FROM "NORMAL" TO RIGHT, TO LEFT AND BACK TO "NORMAL", ALWAYS MAINTAINING ROUND SHAPES)

Mickey ear positions by veteran Disney animator Ward Kimball.

cartoon world, halfway between our world and the plane of pure signs, of alphabets and trademarks.

In the sixty-three years since Mickey Mouse's image was promulgated, the ears, though a bit more organically irregular and flexible than

the classic 1930s appendages, have not been essentially modified. Many other modifications have, however, overtaken that first crude cartoon, born of an era of starker stylizations. White gloves, like the gloves worn in minstrel shows, appeared after those early Twenties movies, to cover the black hands. The infantile bare chest and shorts with two buttons were phased out in the Forties. The eyes have undergone a number of changes, most drastically in the late Thirties, when, as some historians mistakenly claim, they acquired pupils. Not so: the old eyes, the black oblongs that acquired a nick of reflection in the sides, *were* the pupils; the eye-whites filled the entire space beneath Mickey's cap of black, its widow's peak marking the division between these enormous oculi. This can be seen clearly in the face of the classic Minnie; when she bats her eyelids, their lashed shades lower over the full width of what might be thought to

be her brow. But all the old animated animals were built this way from Felix the Cat on; Felix had lower lids, and the Mickey of *Plane Crazy* also. So it was an evolutionary misstep that, beginning in 1938, replaced the old shiny black pupils with entire oval eyes, containing pupils of their own. No such mutation has overtaken Pluto, Goofy, or Donald Duck. The change brought Mickey closer to us humans, but also took away something of his vitality, his alertness, his bug-eyed cartoon readiness for adventure. It made him less abstract, less iconic, more merely cute and dwarfish. The original Mickey, as he scuttles and bounces through those early animated shorts, was angular and wiry, with much of the impudence and desperation of a true rodent.

He was gradually rounded to the proportions of a child, a regression sealed by his Fifties manifestation as the genius of the children's television show, *The Mickey Mouse Club*, with its

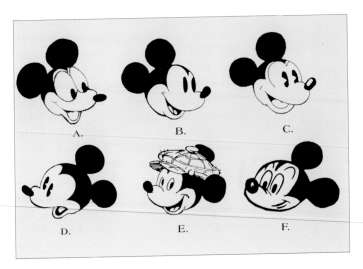

live Mousketeers. But most of the artists in this album, though too young to have grown up, as I did, with the old form of Mickey, have instinctively reverted to it; it is the bare-chested, basic Mickey, with his yellow shoes and oval buttons on his shorts, who is the icon, beside whom his modified later version is a mere mousy trousered pipsqueak.

Mickey eye evolution: A. Mickey in *Plane Crazy* (1928); B. In cartoons of the early 1930s; C. In graphic art of the 1930s; D. Without eye rims, in a 1934 comic strip; E. Mickey with oblong humanoid eyes, c. 1938; F. Mickey in a comic strip of the 1970s.

His first, iconic manifestation had something of Chaplin to it: he was the little guy, just over the border of the respectable. His circular ears, like two minimal cents, bespeak the smallest economic unit, the overlookable democratic man. His name has passed into the language as a byword for the small, the weak—a "Mickey Mouse operation" means an undercapitalized company or minor surgery. Children of my generation—wearing our Mickey Mouse watches, prying pennies from our Mickey Mouse piggy banks (I won one in a third-grade spelling bee, my first intellectual triumph), following his running combat with Pegleg Pete in the daily funnies, going to the local movie-house movies every Saturday afternoon and cheering when his smiling visage burst onto the screen to introduce a cartoon—felt Mickey was one of us, a bridge to the adult world of which Donald Duck was, for all of his childish sailor suit, an irascible, tyrannical member.

Mickey didn't seek trouble, and he didn't complain; instead he rolled with the punches, and surprised himself as much as us when, as in *Brave Little Tailor*, he showed warrior resourcefulness and won, once again, a blushing kiss from dear, all but identical, Minnie. His minimal, decent nature meant that he would ultimately yield, in the Disney animated cartoons, the starring role to combative, sputtering Donald Duck and even to the awkward Goofy with all his "gawshes" and his Gary-Cooper–like gawkiness.

Except for an occasional comeback like the Sorcerer's Apprentice episode of *Fantasia*, Mickey was finished as a star by 1940. But, as with Marilyn Monroe when her career was over, his life as an icon gathered strength. The America that is not symbolized by that imperial Yankee Uncle Sam is symbolized by Mickey Mouse. He is America as it feels to itself—plucky, put-on, inventive, resilient, good-natured, game.

Like America, Mickey has a lot of black blood. This fact was revealed to me in the course of conversation with Saul Steinberg, who, in attempting to depict the racially mixed reality of the New York streets for the super-sensitive and race-blind *New Yorker* of the Sixties and Seventies, hit upon scribbling numerous Mickeys as a way of representing what was jauntily and scruffily and unignorably there. From just the way Mickey swings along in his classic, trademark pose, one three-fingered gloved hand held on high, he is jiving. Along with round black ears and yellow shoes, Mickey has soul. Looking back to such early animations as the early Loony Tunes' Bosko and Honey series (1930–1936) and the Arab figures in Disney's own *Mickey in Arabia* of 1932, we see that blacks were drawn much like cartoon animals, with round button noses and great white eyes creating the double arch of the curious peaked skullcaps. Cartoon characters' rubberiness, their

jazziness, their cheerful buoyance and idleness, all chimed with popular images of African Americans, earlier embodied in minstrel shows and in Joel Chandler Harris's tales of Uncle Remus, which Disney was to make into an animated feature, *Song of the South*, in 1946.

Up to 1950, animated cartoons, like films in general, contained caricatures of blacks that would be unacceptable now; in fact, *Song of the South* raised objections from the NAACP when it was released. In recent reissues of *Fantasia*, a pair of Nubian centaurettes and a pickaninny centaurette who shines the others' hooves have been edited out. Not even the superb crows section of *Dumbo* would be made now. But there is a sense in which all animated cartoon characters are more or less black. Steven Spielberg's hectic tribute to animation, *Who Framed Roger Rabbit*, has them all, from the singing trees of Silly Symphonies to Daffy

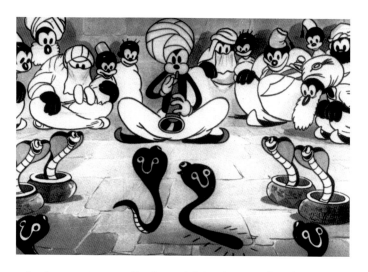

A hot jam session from *Mickey in Arabia*.

Duck and Woody Woodpecker, living in a Los Angeles ghetto, Toonville. As blacks were second-class citizens with entertaining qualities, so the animated shorts were second-class movies, with unreal actors who mocked and illuminated from underneath the real world, the live-actor cinema. Of course, even in a ghetto there are class distinctions. Porky Pig and

Bugs Bunny have homes that they can tend and defend, whereas Mickey started out, like those other raffish stick figures and dancing blots from the Twenties, as a free spirit and a wanderer.

As Richard Schickel has pointed out, "The locales of his adventures throughout the 1930s ranged from the South Seas to the Alps to the deserts of Africa. He was, at various times, a gaucho, teamster, explorer, swimmer, cowboy, fireman, convict, pioneer, taxi driver, castaway, cyclist, fisherman, Arab, football player, inventor, jockey, storekeeper, camper, sailor, Gulliver, boxer" and so forth. He was, in short, a rootless vaudevillian who would play any part that the bosses at Disney Studios assigned him. And though the comic strip, which still persists, has fitted him with all of a white man's household comforts and headaches, it is as an unencumbered drifter whistling along on the road of hard knocks, ready for whatever

adventure waits at the next turning, that he lives in our minds.

Cartoon characters have soul as Carl Jung defined it in his *Archetypes and the Collective Unconscious*: "soul is a life-giving demon who plays his elfin game above and below human existence." Without the "leaping and twinkling of the soul," Jung says, "man would rot away in his greatest passion, idleness." The Mickey Mouse of the Thirties shorts was a whirlwind of activity, with a host of unsuspected skills and a reluctant heroism that rose to every occasion. Like Chaplin and Douglas Fairbanks and Fred Astaire, he acted out our fantasies of endless nimbleness, of perfect weight-lessness. Yet, withal, there was nothing aggressive or self-promoting about him as there was about, say, Popeye. Disney, interviewed in the Thirties, said, "Sometimes I've tried to figure out why Mickey appealed to the whole world. Everybody's tried to figure it out. So far as I know, nobody has.

He's a pretty nice fellow who never does anybody any harm, who gets into scrapes through no fault of his own, but always managed to come up grinning." This was perhaps Disney's image of himself; for twenty years he did Mickey's voice in the films, and would often say, "there's a lot of the Mouse in me." Mickey was a character created with Disney's own pen, and

The comic strip Mickey surrounded by all the comforts and headaches of home.

nurtured on memories of his mouse-ridden Kansas City studio and of the Missouri farm where his struggling father tried for a time to make a living. Walt's humble, scrambling beginnings remained embodied in the mouse, whom the Nazis, in a fury against the Mickey-inspired Allied legions (the Allied code word on D-Day was "Mickey Mouse"), called "the most miserable ideal ever revealed . . . mice are dirty."

But was Disney, like Mickey, just a "pretty nice fellow"? He was until crossed in his driving perfectionism, his Napoleonic capacity to marshal men and take risks in the service of an artistic and entrepreneurial vision. He was one of those great Americans, like Edison and Henry Ford, who invented themselves in terms of a new technology. The technology—in Disney's case, film animation—would have been there anyway, but only a few driven men seized the full possibilities, and made empires. In the

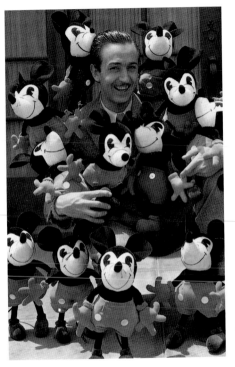

Walt Disney c. 1930
surrounded by
Mickey dolls.

dozen years between *Steamboat Willie*
and *Fantasia*, the Disney studios took
the art of animation to new heights of

ambition and accomplishment it would never have reached otherwise, and Disney's personal zeal was the animating force. Disney had created an empire of the mind, and its emperor was Mickey Mouse.

The Thirties were Mickey's conquering decade. His image circled the globe. In Africa, tribesmen painfully had tiny mosaic Mickey Mouses inset into their front teeth, a South African tribe refused to buy soap unless the cakes were embossed with Mickey's image, and a revolt of some native bearers was quelled when the safari masters projected some Mickey Mouse cartoons for them. Nor were the high and mighty immune to the elemental appeal of the Mouse—both King George V and Franklin Delano Roosevelt insisted that all film showings they attended include a dose. While other popular phantoms, like Felix the Cat, have faded, Mickey has settled into the national collective consciousness. The television program

revived him for my children's generation, and the theme parks make him live for my grandchildren's. Yet survival cannot be imposed solely through weight of publicity; Mickey's persistence springs from something unhyped, something timeless, in the image that has allowed it to pass in status from a fad to an icon.

To take a bite out of our imaginations, an icon must be simple. The ears, the wiggly tail, the red shorts, give us a Mickey. Donald Duck and Goofy, Woody Woodpecker and Bugs Bunny are inextricably bound up with the draftsmanship of the artists who make them move and squawk, but Mickey floats free. It was Claes Oldenburg's work that first alerted me to the fact that Mickey Mouse had passed out of the realm of commercially generated image into that of artifact, so that the basic configuration, like that of hamburgers and pay telephones, could be used as an immediately graspable referent in a piece of

art. The young Andy Warhol had committed Dick Tracy, Nancy, Batman, and Popeye to canvas, but not, until 1981, Mickey Mouse.

Perhaps Pop Art could most resonantly recycle comic strips which have a romantic appeal to adolescents. Mickey's appeal is preromantic, a matter of latency's relatively abstract manipulations. Hajime Sorayama's shiny piece of airbrush art and Gary Baseman's scribbled scraps, both in this volume, capture textures of the developmental stage at which the Mouse's image penetrates. Sorayama, by adding a few features not present in the cartoon image—supplying knobs to the elbows and knees and some anatomy to the ears—subtly carries forward Disney creativity without violating it. Baseman's reference to Mousketeer ears is important; their invention further abstractified Mickey and turned him into a kind of power we could put on while remaining, facially, ourselves. The ancient notion

of the transforming hat—crowns, dunce caps, "thinking caps," football helmets, spaceman gear—acquires new potency in the age of the television set, which sports its own "ears," gathering magic from the very air. As John Berg's painting shows us, ears are everywhere.

To recognize Mickey, as Heinz Edelmann's drawing demonstrates, we need very little. Round ears will do it. A Disney gadget, advertised on television, is a camera-like box that spouts bubbles when a key is turned; the key consists of three circles, two mounted on a larger one, and the image is unmistakably Mickey. Like yin and yang, like the Christian cross and the star of Israel, Mickey can be seen everywhere—a sign, a rune, a hieroglyphic trace of a secret power, an electricity we want to plug into. Like totem poles, like African masks, Mickey stands at that intersection of abstraction and representation where magic connects.

Milton Glaser's charming reprise of Mickey wearing glasses, though still engaged in his jivey stride, lightly touches on the question of iconic mortality. Usually, cartoon figures do not age, and yet their audience does age, as generation succeeds generation, so that a weight of allusion and sentimental reference increases. To the movie audiences of the early Thirties, Mickey Mouse was a piping-voiced live wire, the latest thing in entertainment; by the time of the Sorcerer's Apprentice in *Fantasia*, he was already a somewhat sentimental figure, welcomed back. *The Mickey Mouse Club*, with its somewhat melancholy pack-leader Jimmie Dodd, created a Mickey more removed and marginal than in the first. The generation that watched it grew up into the rebels of the Sixties, to whom Mickey became camp, a symbol of U.S. cultural fast food, with a touch (see the drawing by Rick Griffin) of the old rodent raffishness. Stung by the studio strike of 1941, Walt moved to

Opposite: Mickey strutting on stage.

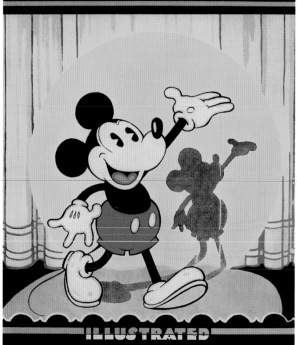

the right politically, but Mickey remains one of the Thirties proletariat, not uncomfortable in the cartoon-rickety, cheerfully verminous crash pads of the counterculture. At the Florida and California theme parks, Mickey manifests himself as a short real person wearing an awkward giant head, costumed as a ringmaster; he is in danger, in these Nineties, of seeming not merely venerable kitsch but part of the great trash problem, of becoming one more piece of visual litter being moved back and forth by the bulldozers of consumerism.

But never fear, his basic goodness will shine through. Beyond recall, perhaps, is the simple love felt by us of the generation that grew up with him. I remember crying when the local newspaper, cutting down its comic pages to help us to win World War II, eliminated the Mickey Mouse strip. I was old enough, nine or ten, to write an angry letter to the editor. In fact, the strips had been eliminated by

the votes of a readership poll, and my indignation and sorrow stemmed from my incredulous realization that not everybody loved Mickey Mouse as I did. In "The Dogwood Tree," an account of my boyhood written over thirty years ago, I find these sentences concerning another boy, a rival: "When we both collected Big Little Books, he outbid me for my supreme find (in the attic of a third boy), the first Mickey Mouse. I can still see that book. I wanted it so badly, its paper tan with age and its drawings done in Disney's primitive style, when Mickey's black chest is naked like a child's and his black eyes are two nicked oblongs." And I once tried to write a short story called "A Sensation of Mickey Mouse," trying to superimpose on adult experience, as a shiver-inducing revenant, that indescribable childhood sensation—a rubbery taste, a licorice smell, a feeling of supernatural clarity and close-in excitation that Mickey Mouse gave me, and gives me,

much dimmed by the years, still. He is a "genius" in the primary dictionary sense of "an attendant spirit," his vulnerable bare black chest, his touchingly big yellow shoes, the mysterious place at the back of his shorts where his tail came out, the little cleft cushion of a tongue, red as a valentine and glossy as candy, always peeping through the catenary curves of his undiscourageable smile. Not to mention his ears.

For many of these facts I am indebted to Mickey Mouse: Fifty Happy Years, *introduced by David Bain and edited by Bain and Bruce Harris (Harmony Books, 1977). Another valuable source was* Enchanted Drawings: The History of Animation, *by Charles Solomon (Alfred A. Knopf, 1989).*

FOREWORD

CRAIG YOE and
JANET MORRA-YOE

We have loved Mickey Mouse ever since we first saw him flicker across the TV screen. On weekday afternoons we'd draw the living room curtains, put on our Mouseketeer ears, and enter his little black-and-white world.

You could say we grew up with Mickey, except that we didn't quite grow up. Now we're big kids, and we still love to have Mickey around. Framed pictures of Mickey look down at us from our studio walls. Mickey Mouse T-shirts hang on our skinny frames. And, since our red and yellow, black and white bathroom is lined floor to ceiling with Mickey memorabilia, he's the first thing we see in the morning and the last thing we see at night.

Mickey is constantly floating around in our brains, so when we hit upon the idea of creating a book of artists' interpretations of Walt's mouse, it seemed a natural.

Fine artists. Folk artists, animators, and illustrators. Punk artists and cartoonists. Pop artists, pop star. Artists from South America, Europe, the Soviet Union, Asia, and America. The famous and the hitherto unknown. The Mouse is perhaps the only muse that could have brought together such a varied roster of talented artists eager to lift their brushes, chisels, needles and thread, ink pens, cameras, and computer mouses in tribute. To Mickey Mouse — long may he live!

New York City
September, 1991

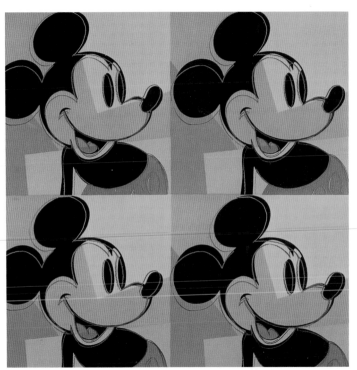

ANDY WARHOL
Mickey Mouse (Myths Series), 1981
Silkscreen ink on synthetic polymer
paint on canvas
152.4 x 152.4

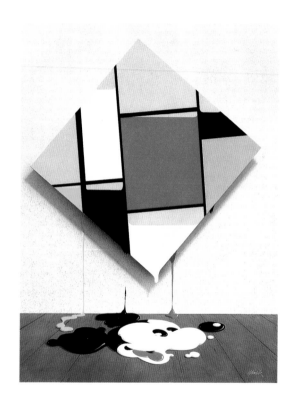

MICK HAGGERTY
Mickey-Mondrian, 1978
Acrylic on board
46.3 x 35.5

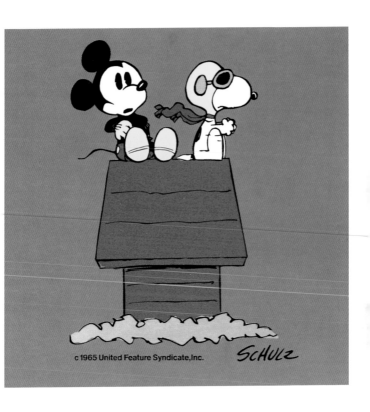

c 1965 United Feature Syndicate,Inc.

SCHULZ

CHARLES M. SCHULZ
Untitled, 1991
Pen and ink, computer colored
22.9 x 24.7

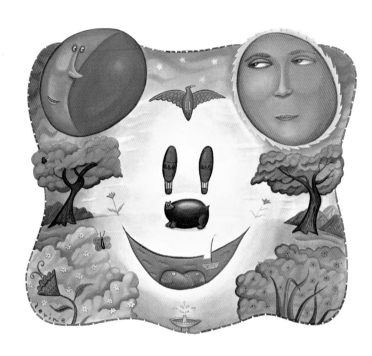

ANDY LEVINE
Mickeyscape
Acrylic
37.5 x 40

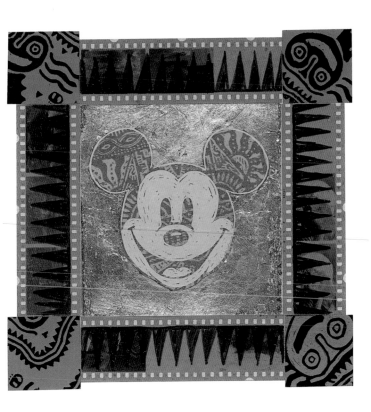

JOSÉ ORTEGA
GuantanaMickey
Scratchboard, gold leaf, film
19 x 19

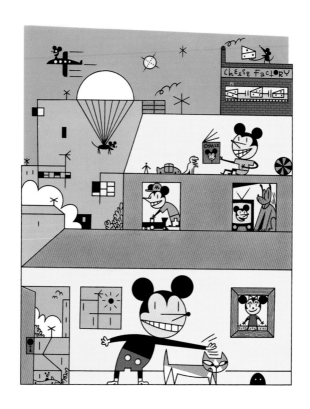

J. D. KING
The House of Mouse
Ink and color film
33 x 25

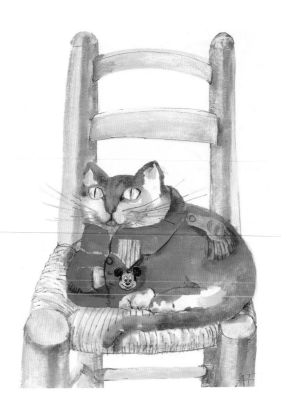

ANDRÉ FRANÇOIS
The Battle of Trafalgar, 1987–91
Collage and mixed media
· 61.6 x 46.4

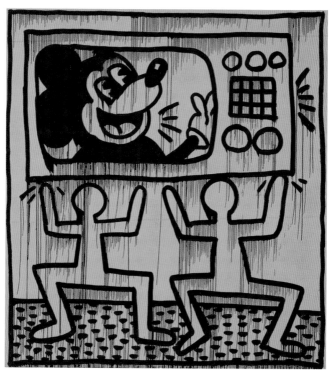

KEITH HARING

Untitled, 1982
Sumi ink and acrylic on canvas
246.5 x 235.1

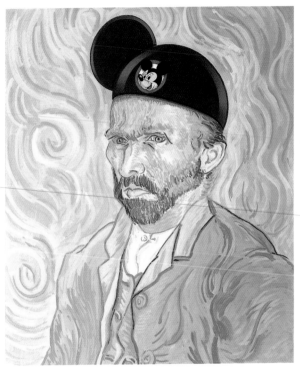

BOB BUCCELLA
Vincent Van Goghs to Disneyland,
1987
Acrylic and gouache
24.8 x 21

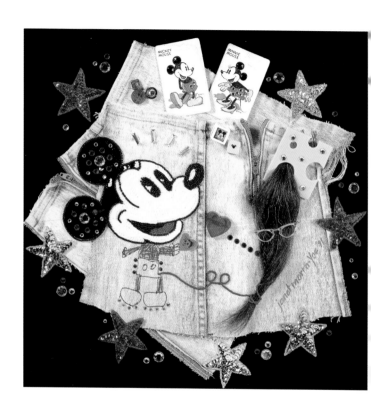

JANET MORRA-YOE
The Game of Love
Mixed media
50 x 50

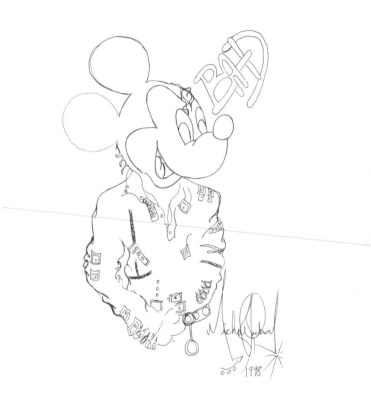

MICHAEL JACKSON

Bad, 1998
Pen
28 x 21.6

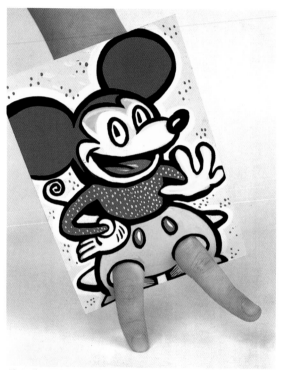

Photo: Sherman Bryce Model: Avarelle Yoe

PAMELA HOBBS
Dancing Mickey
Acrylic on paper
20 x 10.7

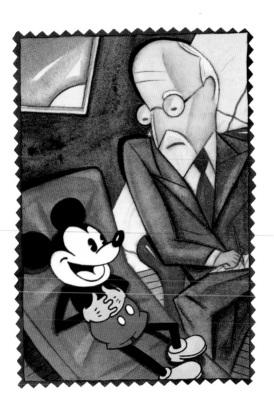

RUSSELL O. JONES
The Psychoanalysis of Mickey, 1988
Watercolor
14 x 10

HOW TO DRAW SEVEN CIRCLES

BY SEYMOUSE CHWAST

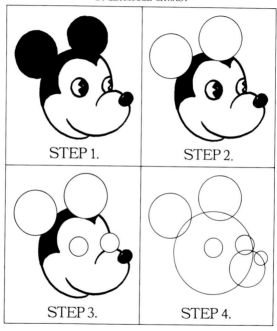

STEP 1.

STEP 2.

STEP 3.

STEP 4.

SEYMOUR CHWAST
How to Draw 7 Circles
Pen
43.3 x 28

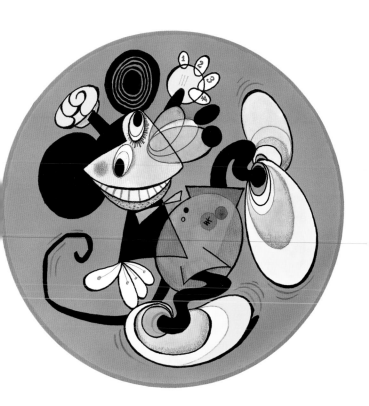

WARD KIMBALL
Design for an Experimental Waldorf Salad Plate
Acrylic, ink and pencil
29 x 29

SUZY AMAKANE
Look for Minnie!
Acrylic on canvas
100 x 100

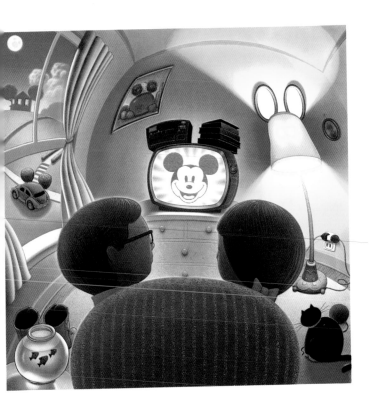

JOHN BERG
Echoes
Acrylic
42.5 x 42.5

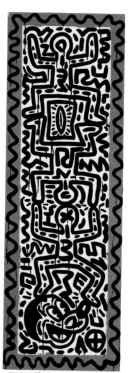

KEITH HARING

Untitled, 1982
Marker and enamel on wood
135.8 x 46.9

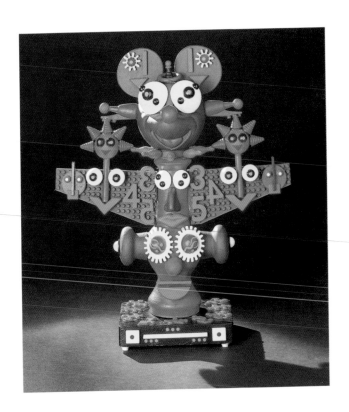

DUG MILLER
Mickey Totem, 1989
Found objects, fluorescent paint
44.5 x 37

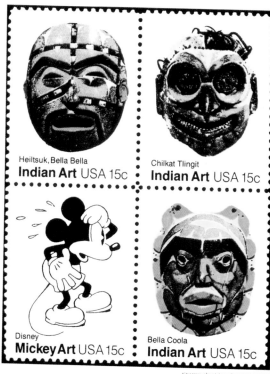

Heiltsuk, Bella Bella
Indian Art USA 15c

Chilkat Tlingit
Indian Art USA 15c

Disney
Mickey Art USA 15c

Bella Coola
Indian Art USA 15c

BRADBURY THOMPSON
Mickey and the Masks, 1980–91
Mixed media
14.5 x 11.4

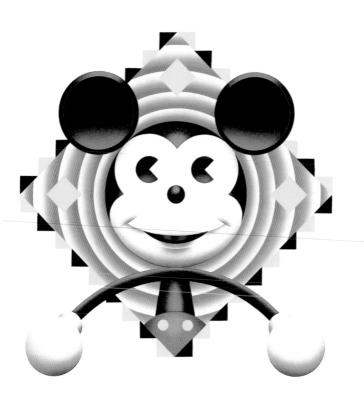

JOSÉ CRUZ
Mickey the Mouse
Acrylic
34.2 x 29

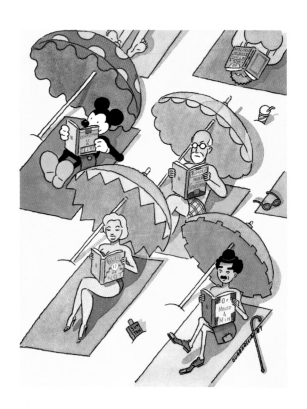

STEVEN GUARNACCIA
On the Beach, 1987
Pen and ink, watercolor
41.1 x 15.1

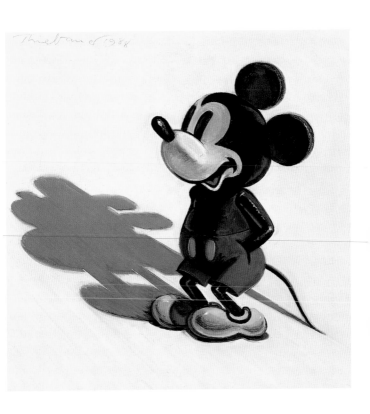

WAYNE THIEBAUD
Toy Mickey, 1988
Oil on wood
30.5 x 30.5

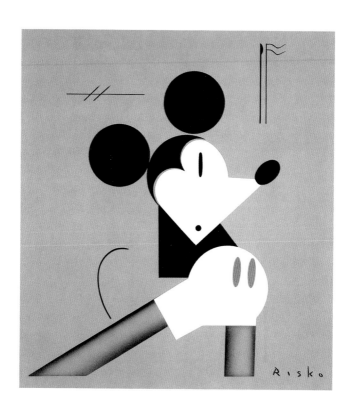

ROBERT RISKO
Minimal Mickey
Collage
50 x 37

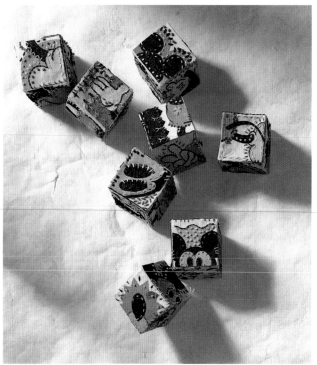

Photo: Bill Timmerman

ANN MORTON HUBBARD
Mickey Mouse in 30.375 Cubic Inches (Detail)
Paper and embroidery floss
38.5 x 22

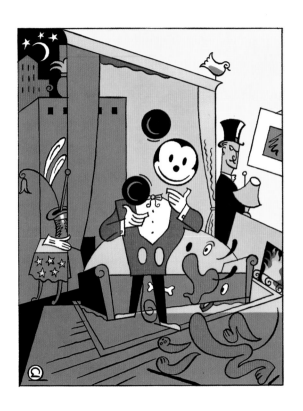

EVER MEULEN
Watch This One
Pen and ink,
overlay on blue bristol
22.3 x 17.2

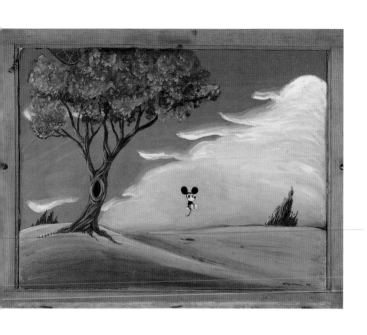

PATRICK McDONNELL
Floating Mickey, 1990
Oil on graphite
53.4 x 63.7

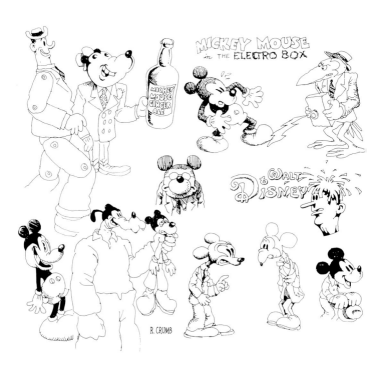

R. CRUMB
Untitled, 1966–1967
Pen and ink
Sketchbook details

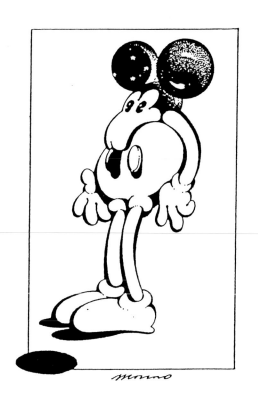

VICTOR MOSCOSO
Untitled, 1970
Pen and ink
20.3 x 15.2

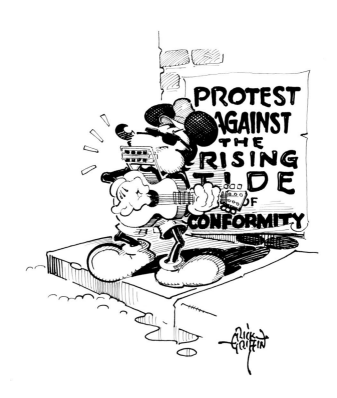

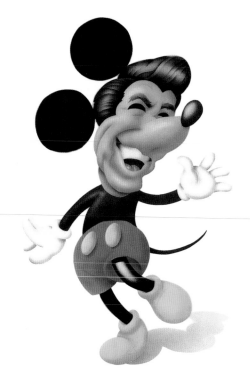

ROBERT GROSSMAN
Ronald Reagan, 1967
Watercolor
50.7 x 38.1

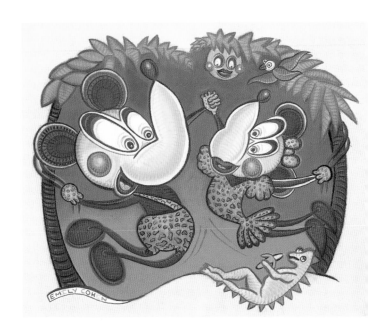

EMILY COHEN
Me Mickey, You Minnie
Pastel
28 x 30.5

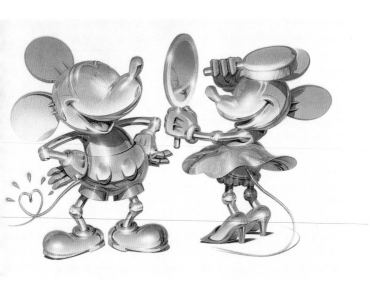

HAJIME SORAYAMA
Untitled
Acrylic on board
51.5 x 36.4

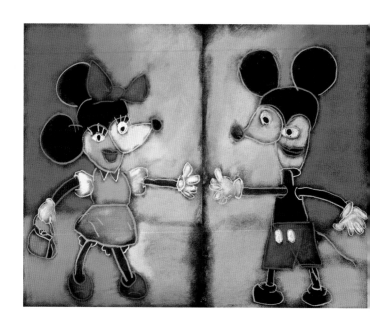

ANDRZEJ DUDZINSKI
The Mouses
Oil crayon & pastel on paper
Diptych, 70.6 x 45.4

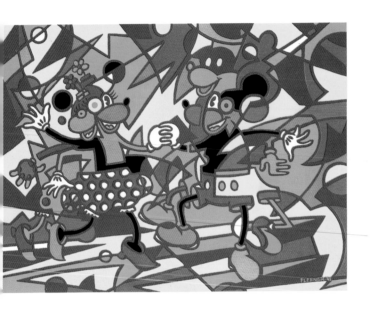

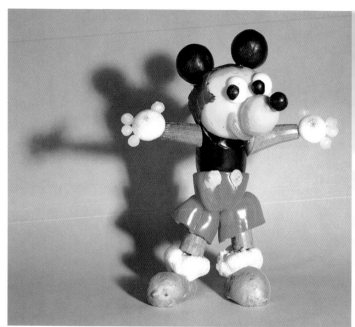

Photo: Gerald Janssen

ADAM KURTZMAN
Mickey's Salad Days
Fruit and vegetables
50 x 38 x 22

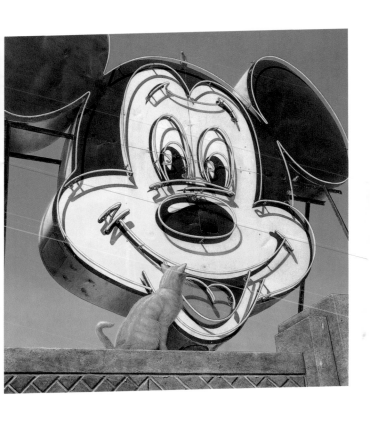

THOMAS GIESEKE
Cat and Mouse
Mixed media
48.5 x 48.5

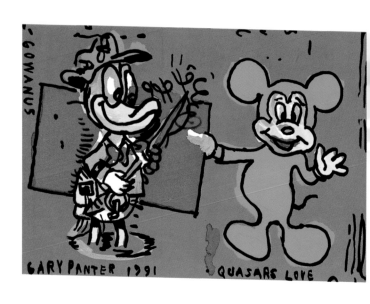

GARY PANTER
Quasars Love
Acrylic on paper
35.5 x 50.5

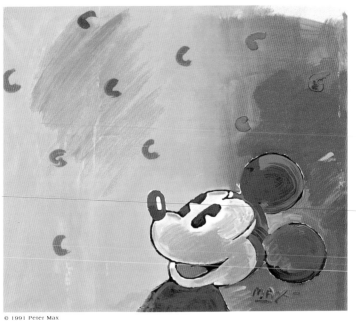

PETER MAX
Mickey Mouse
Acrylic on paper
52.1 x 60.9

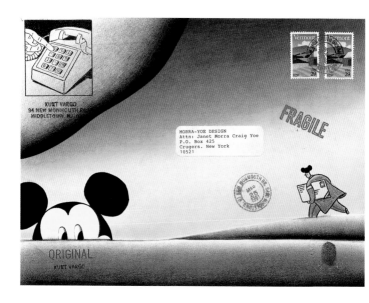

<small>TERRY ALLEN</small>
Meese's Pieces
Gouache
63.6 x 42.1

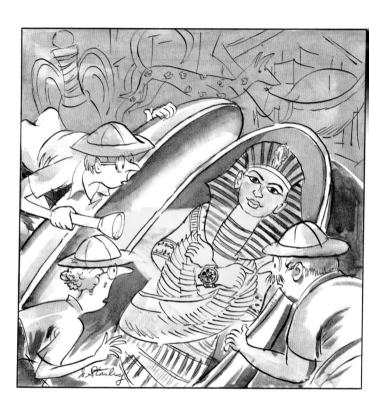

JOHN STANLEY
The Fabulous Treasure of King Tutankhamun
Ink and watercolor
26.7 x 26.7

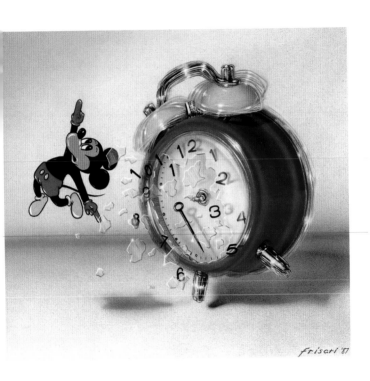

FRANK FRISARI
Mickey Takes a Lickin', 1987
Acrylic on illustration board
23 x 25.5

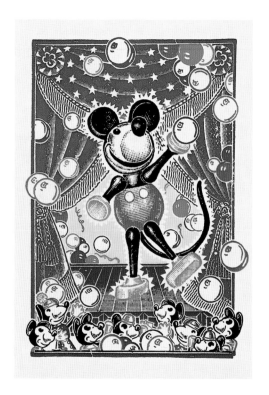

JOHN CRAIG

Mickey Shares His Thoughts
Collage and overlays
24.2 x 17.8

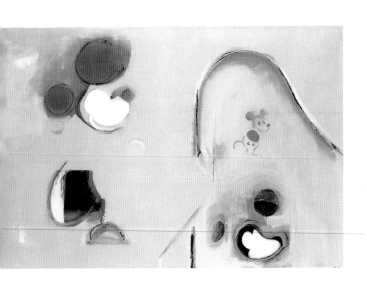

PATRICK McDONNELL
Mickey Mouse Painting, 1990
Oil, acrylic, latex
101.6 x 152.4

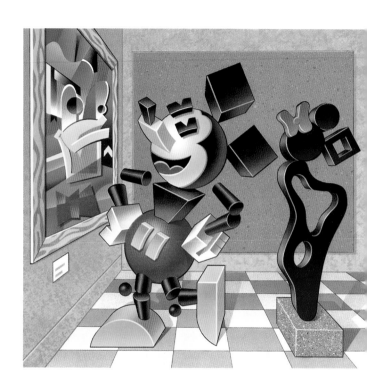

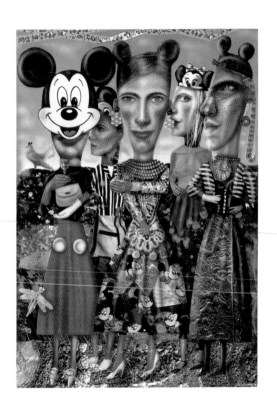

JANET WOOLLEY
Mickey Mouse Fancy Dress
Collage and Acrylic
60 x 42

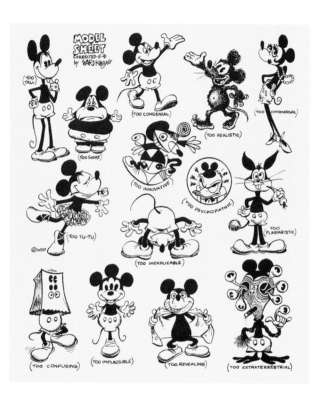

WARD KIMBALL
Model Sheet, 1985–91
Pen and ink
31.2 x 26

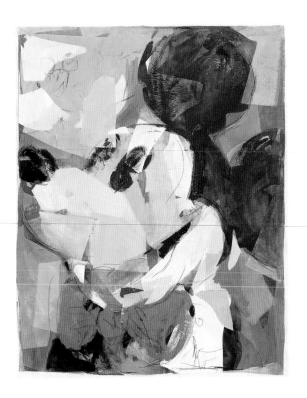

KATSUYA ISE

Mickey Mouse, 1985
Acrylic and paper on canvas
160 x 130

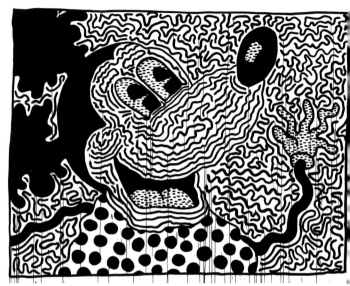

KEITH HARING
Untitled, 1982
Sumi ink on paper
182.9 x 238.2

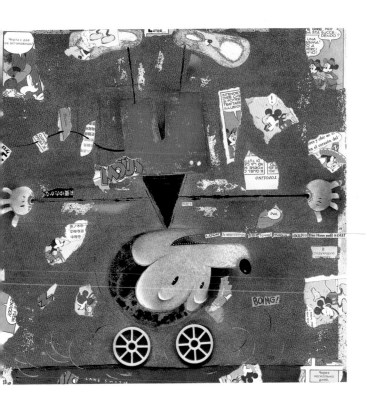

LANE SMITH
Mickey Machine
Mixed media
27 x 27

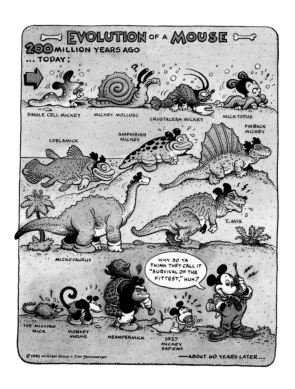

WILLIAM STOUT
JIM STEINMEYER
Evolution of a Mouse
Pen and ink, watercolor
34.3 x 27.3

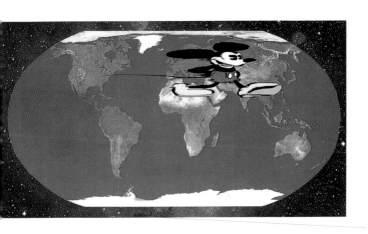

FRANK OLINSKY
Truckin'
Mixed media
21 x 37.8

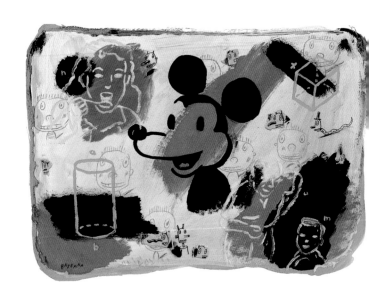

GARY BASEMAN
First Haircut
Mixed media
27.5 x 38

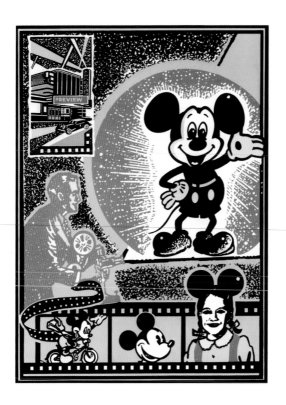

CHRIS SPOLLEN
A Day in the Life of Mickey
Letrachrome print
38.2 x 28.2

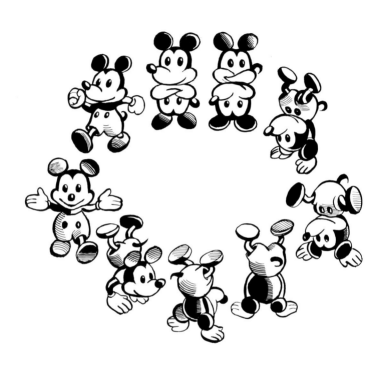

DAVID SUTER
Untitled
Pen and ink
35.5 x 40

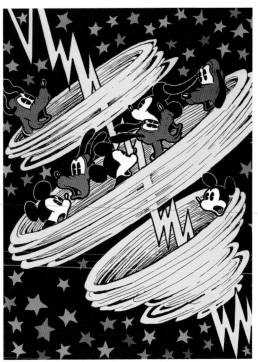

Special thanks to Bill Spicer, Glenn Bray, and Monte Wolverton

BASIL WOLVERTON

Untitled, c.1935
Pen and ink
15.3 x 14.6

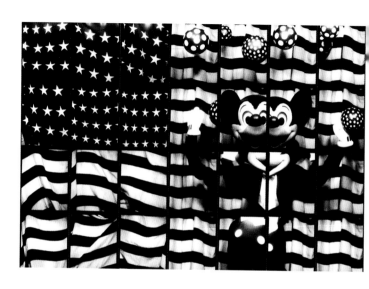

HERMAN COSTA
Mickey Plays Ball:
Stars and Stripes Version
7 uncut (4-frame) B&W
photobooth strips
20.4 x 28.3

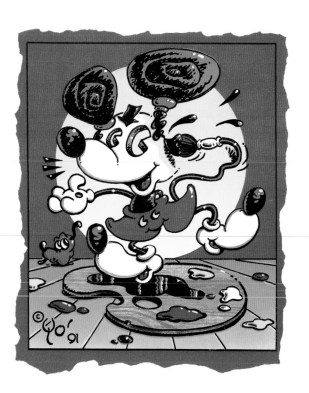

CRAIG YOE
Self Portrait
Mixed media
38 x 33

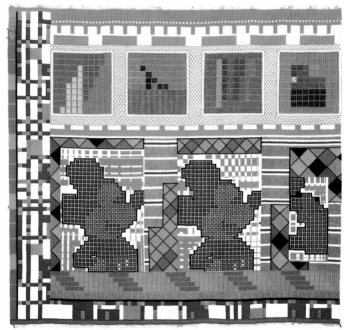

SIR EDUARDO PAOLOZZI

DIRECTOR OF WEAVING: ARCHIE BRENNAN
WEAVERS: FRED MANN, HARRY WRIGHT,
DOUGLAS GRIERSON AND MAUREEN HODGE
The Whitworth Tapestry, 1967
152.3 x 172.8

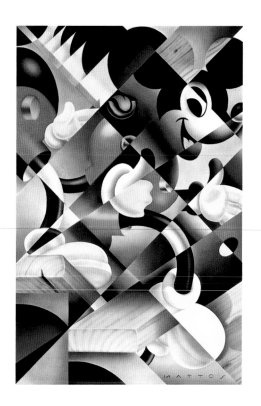

JOHN MATTOS

Mickey Descending a Staircase, 1988
Ink
43.2 x 28

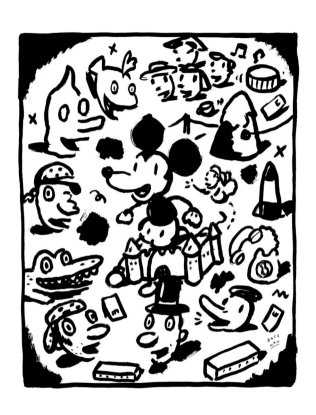

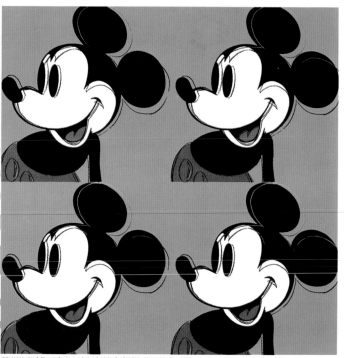

ANDY WARHOL
Mickey Mouse (Myths Series), 1981
Silkscreen ink on synthetic polymer
paint on canvas
152.4 x 152.4

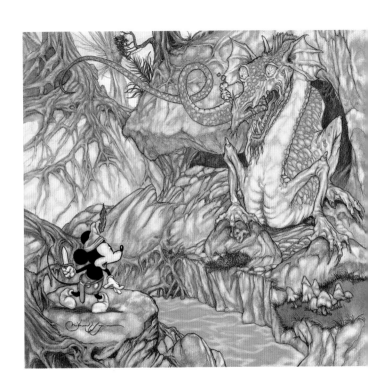

MICHAEL R. HAGUE
Mickey, the Dragon Slayer
Watercolor
28 x 28

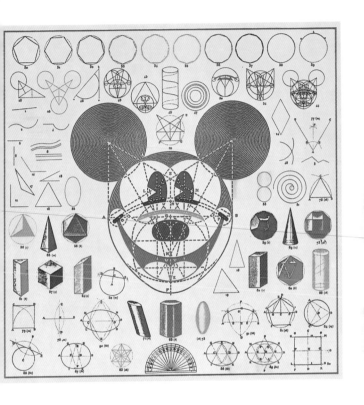

JOHN CRAIG

Proof
Collage and overlays
32 x 30.7

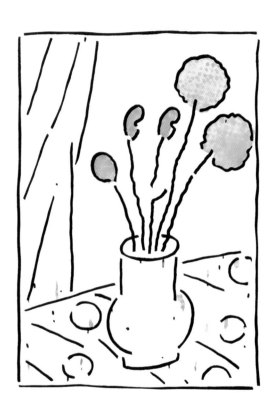

HEINZ EDELMANN
Untitled
Mixed media
20.5 x 14.6

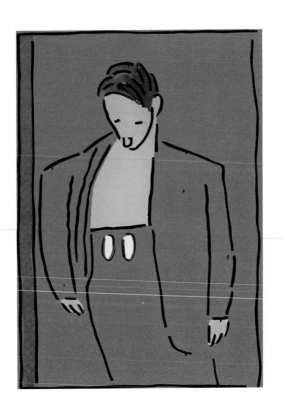

HEINZ EDELMANN
Untitled
Mixed media
20.5 x 14.6

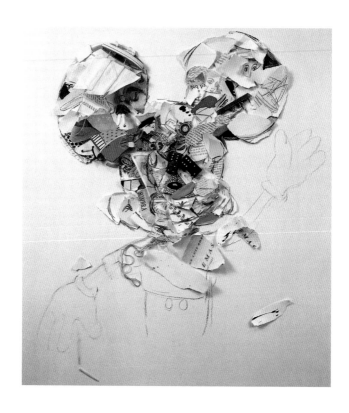

LILIANA PORTER
El Ratón Mickey (Detail), 1990
Mixed media collage
106.7 x 76.2

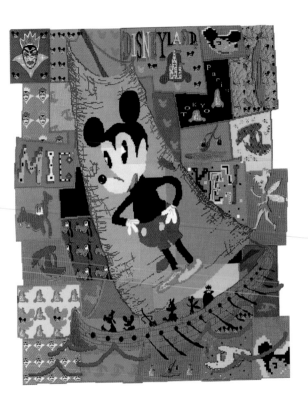

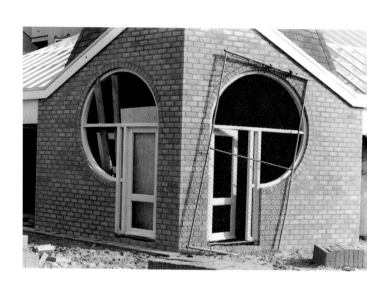

WILLEM DE BOER
Mickey Mouse Building, 1989
Photo
17 x 25.5

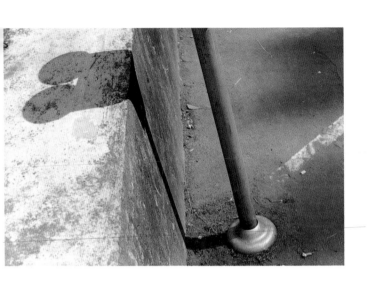

WILLEM DE BOER
Mickey Mouse Parking Meter, 1980
Photo
17 x 25.5

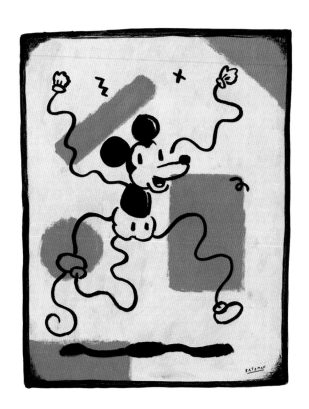

GARY BASEMAN
Rubber Legs Mickey
Ink and acrylic
51 x 41

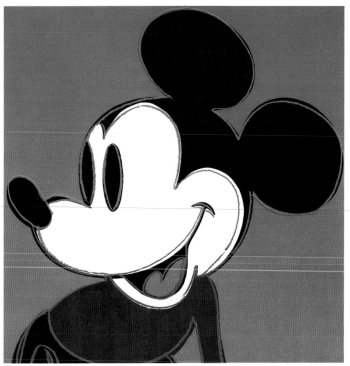

ANDY WARHOL
Mickey Mouse (Myths Series), 1981
Silkscreen ink on synthetic polymer
paint on canvas
152.4 x 152.4

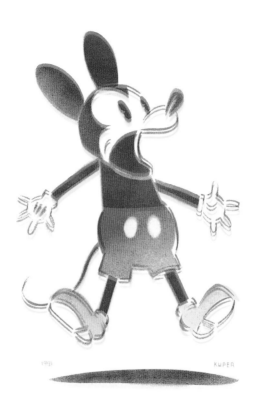

PETER KUPER
#@S&!
Stencil with enamel paint
42.5 x 35.5

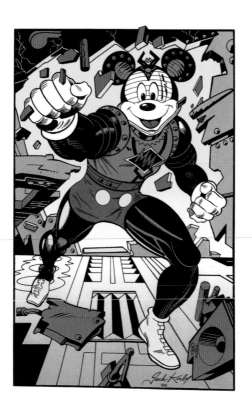

JACK KIRBY
INKER: MICHAEL E. THIBODEAUX
COLORIST: CRAIG YOE
Muscle Mouse
Ink, hand separated color
40.2 x 25.5

Courtesy: Galerie Berggruen, Paris Photo: François Poivret

EDUARDO ARROYO

Mickey, 1986
Collage and painting
44 x 29.5

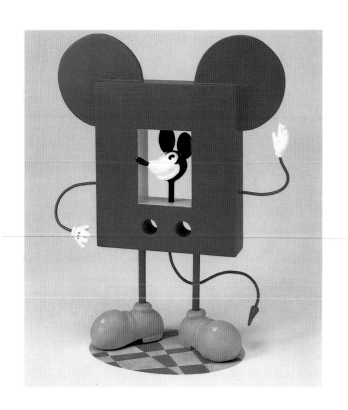

DAVE CALVER
Standing Mickey #1
Mixed media
30.5 x 20.4 x 10.2

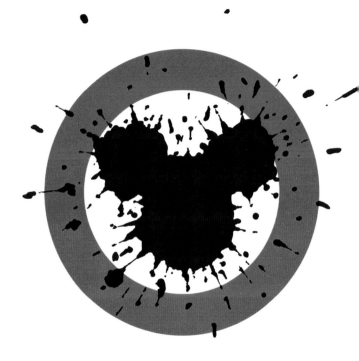

MIKE FINK
Minky Mouse, 1983
Ink and overlay
5 x 5

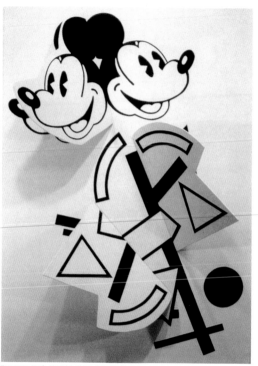

Courtesy: Ruth Siegel Gallery, New York.

ALEXANDER KOSOLAPOV
Mickey-Lissitzky, 1986
Acrylic on canvas, board
167.6 x 121.9 x 45.7

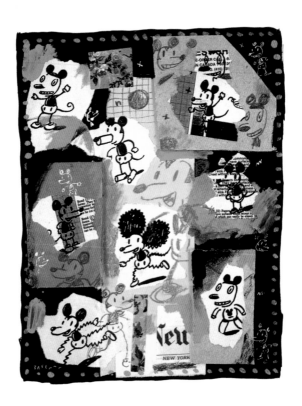

GARY BASEMAN
My Mind
Collage
34.5 x 28

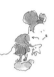

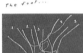

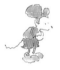

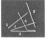

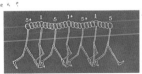

R. O. BLECHMAN
Mickey Goes to Hollywood
Mixed media
30 x 28

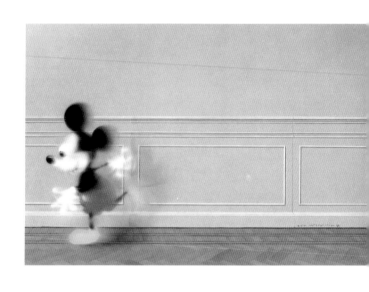

BEN VERKAAIK
Untitled, c.1987
Oil on wood
45.7 x 60.9

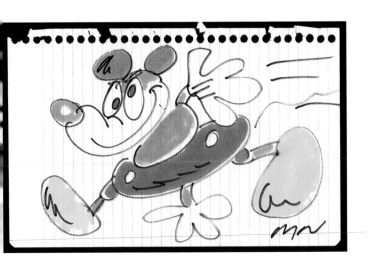

MARK NEWGARDEN
Instantaneous Gratification
Marker on line paper
21 x 30

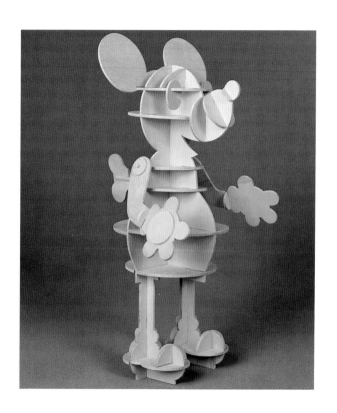

WILLIAM SHELLEY
Das Maus Puzzle, 1989
Birch
68.5 x 33

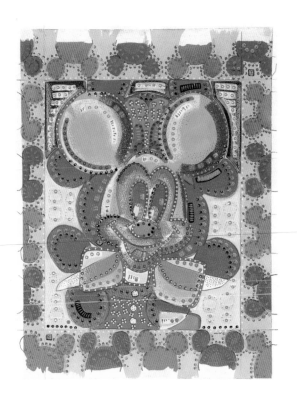

MARK WIENER

Mark's Mickey with Bow Tie II
Mixed Media
44.2 x 30.4

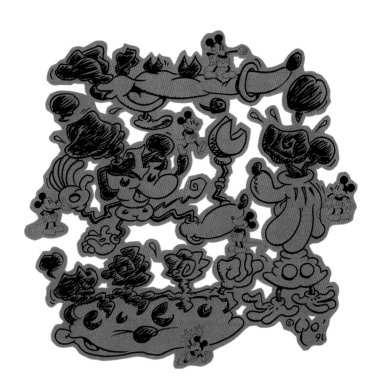

CRAIG YOE

Mickeys, Not Mickeys
Mixed media
28.5 x 28.5

CRAIG YOE
Mickeys, Not Mickeys
Mixed media
28.5 x 28.5

J. OTTO SIEBOLD
Mr. Mickey's Lot
Mac computer

∞

ERICA BOGIN
Hi There, Hey There, Ho There, 1990
Collage
30 x 45.2

LESLEY SCHIFF
Untitled
Color laser print
22 x 31.9

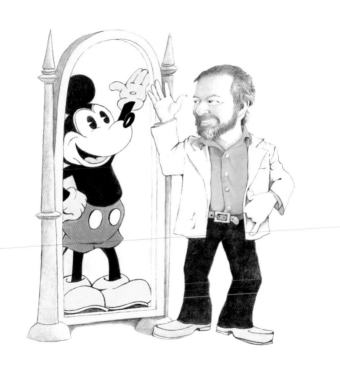

MAURICE SENDAK
Untitled, c.1978
Tempera and brush
15.3 x 11.5

LOU BEACH
Moody Mouse, 1983
Collage
31 x 27

JOHN CEBALLOS
Mickey's Mission, 1988
Acrylic
48.3 x 38.1

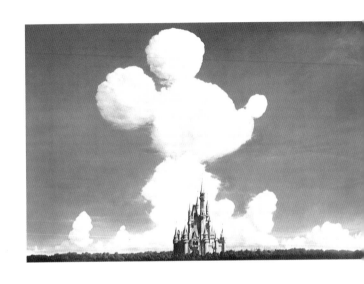

AKIRA YOKOYAMA
*Summer Vacation of Dreams and
Magic*, 1985
Gouache, acrylic and color inks
65 x 103

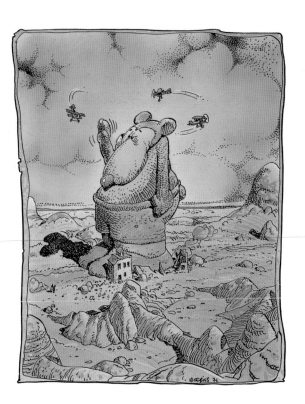

MOEBIUS
Le Petit Mickey, 1979
Pen and ink, color inks
25.5 x 30.5

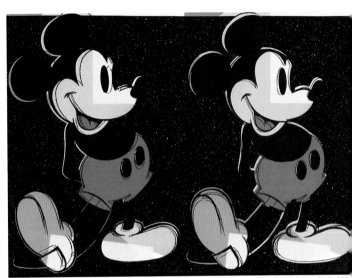

ANDY WARHOL
Double Mickey Mouse, 1981
Silkscreen ink on synthetic polymer
paint on canvas
152.4 x 152.4

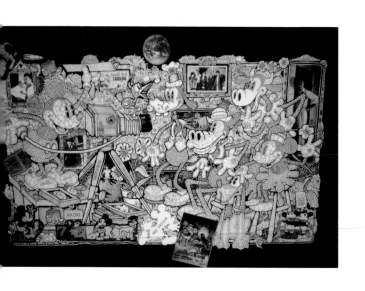

JOHN FAWCETT
Mickey Is Not a Mouse—Mickey Is
Great Art #2, 1985
Mixed media, pen and ink
96.5 x 129.5

WILLIAM STEIG
Mickey Mouse I
Ink and watercolor
18.5 x 25.5

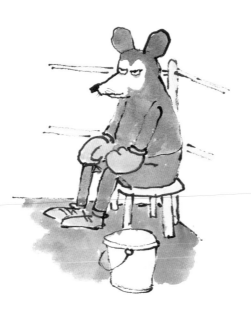

WILLIAM STEIG
Mickey Mouse II
Ink and watercolor
18.5 x 25.5

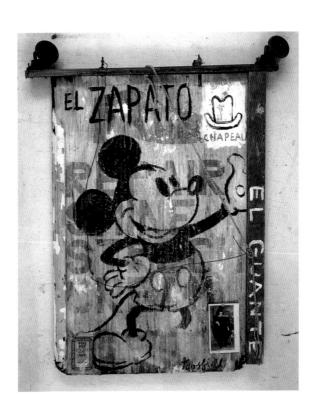

JOSH GOSFIELD
El Zapato
Mixed media
89 x 79

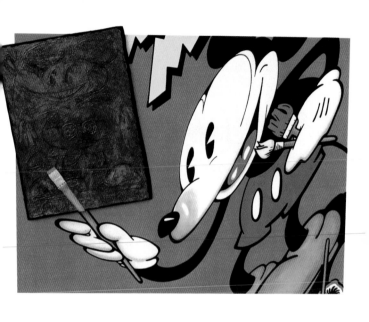

JOHN FAWCETT
Dubuffet's Mouse, 1990
Acrylic
91.4 x 122

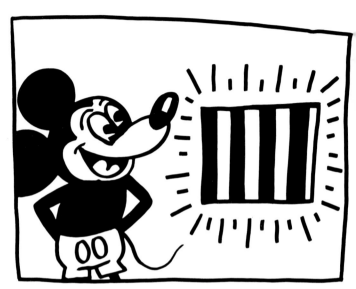

KEITH HARING
Untitled, 1981
Marker on paper
50.6 x 65.8

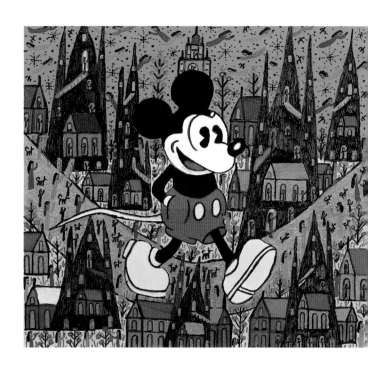

HOWARD FINSTER
*Howard Finster Puts Mickey Mouse
in a Kid's World* (Detail)
Enamel on wood
52.1 x 56

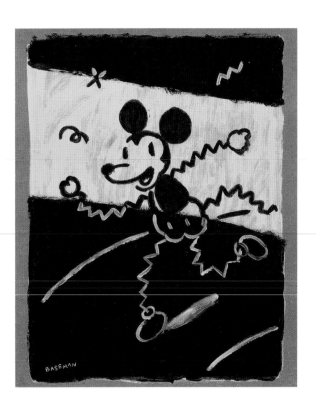

GARY BASEMAN
Electrical Current
ink and acrylic
50.7 x 40.5

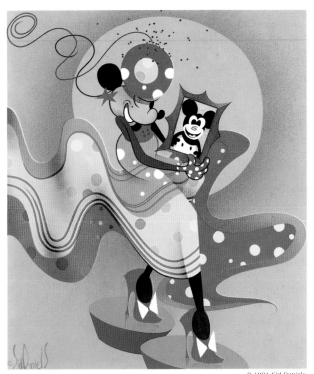

© 1991 Sid Daniels

SID DANIELS

Star Struck
Acrylic on canvas
122 x 106.6

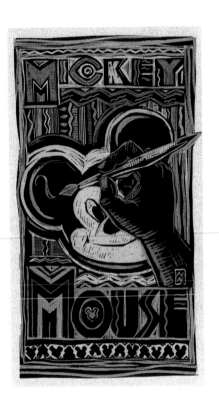

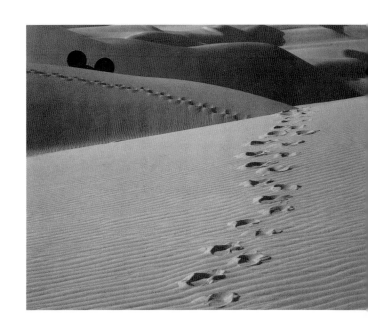

SAUL BASS
Mickey in the Mojave
Color photo copy and overlay
20.3 x 25.5

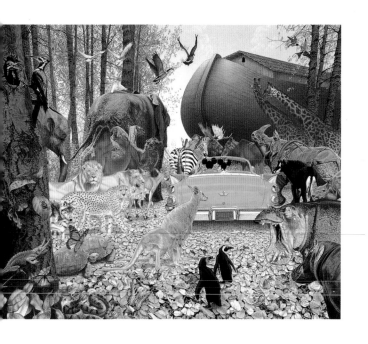

SHELLEY BROWNING
Noah's Ark, 1987
Acrylic
35.5 x 43.5

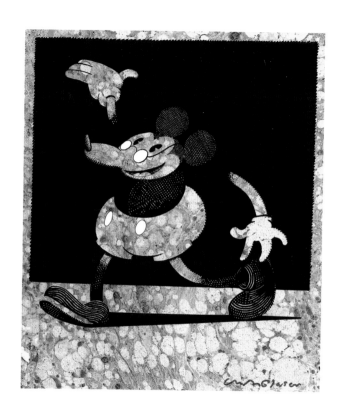

MILTON GLASER
Mickey Mouse Grows Old
Ink, ornamental paper
30 x 25.5

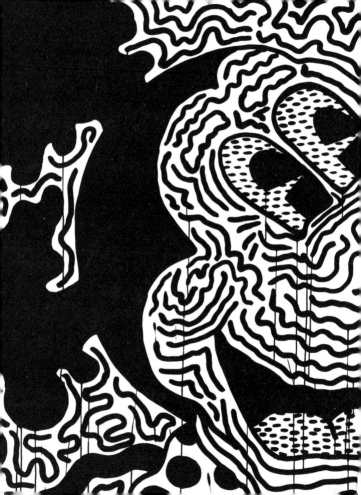